By looking at art with children, you can help them develop their innate capacities for careful observation and creative imagination. *People* focuses on portraits and other pictures of people. You'll find a wide range of expressions, gestures, poses, and settings. Children can begin by naming different things they see. You can ask them how they recognize these things, and how each thing might relate to their own lives. You can also lead children to see more elements in each picture, and encourage them to imagine stories based on what their eyes tell them. There are notes at the back of the book to help.

Enjoy looking together!

People

Philip Yenawine

People

The Museum of Modern Art, New York

Permissions and copyright notices:
Pages 1, 15: © 2006 Estate of Pablo Picasso /Artists Rights Society (ARS), New York
Page 3: © Fernando Botero, courtesy, Marlborough Gallery, New York
Pages 5, 18: © 2006 Artists Rights Society (ARS), New York /ADAGP, Paris
Page 8: © 2006 Artists Rights Society (ARS), New York /VG Bild-Kunst, Bonn
Page 10: © Kenneth Heyman
Page 14: © Lucien Freud
Page 17: © Artists Rights Society (ARS), New York /Pro Litteris, Zurich

Second edition 1999
Third edition 2006

Library of Congress Control Number: 92011203
ISBN: 978-0-87070-174-0

Published by The Museum of Modern Art
11 West 53 Street
New York, New York 10019
(www.moma.org)

Distributed in the United States and Canada by D.A.P., Distributed Art Publishers, New York

Distributed outside the United States and Canada by Thames & Hudson Ltd., London

Front cover: Hilaire-Germain-Edgar Degas, *At the Milliner's*. c. 1882.
Pastel on paper mounted on board, 27 $^5/_8$ x 27 $^3/_4$" (70.2 x 70.5 cm).
Gift of Mrs. David M. Levy

Back cover: Detail of Alice Neel, *Benny and Mary Ellen Andrews*. 1972
Oil on canvas, 60 x 50" (152.2 x 127 cm)
Gift of Agnes Gund, Blanchette Hooker Rockefeller Fund,
Arnold Saltzman Fund, and Larry Aldrich Foundation Fund (by exchange)

Printed in China

Artists make pictures of people.

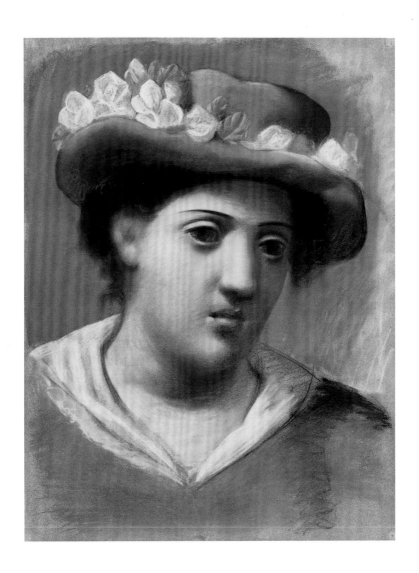

Many pictures tell stories. A story can be about someone who is thoughtful and serious...

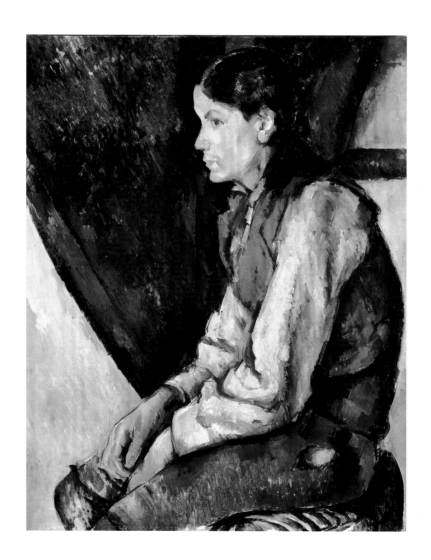

Paul Cézanne. *Boy in a Red Vest*

or about a person who is slightly silly.
Why, do you think, is this girl smiling?

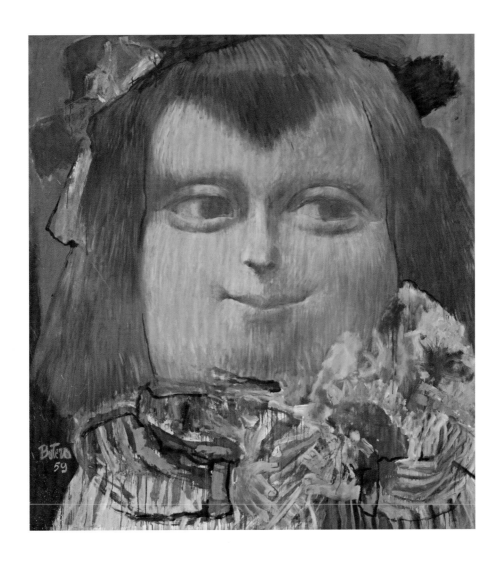

Fernando Botero. *Mona Lisa, Age Twelve*

People can be doing things. What is going on in this picture?

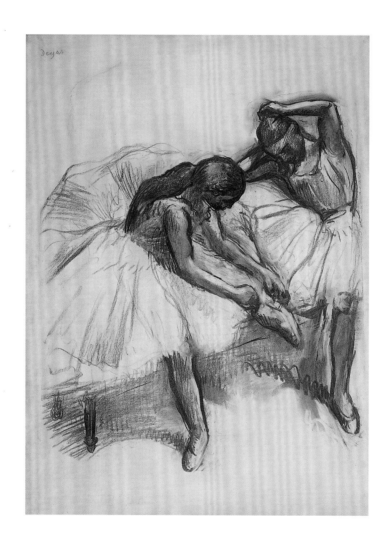

Hilaire-Germain-Edgar Degas. *Two Dancers*

Or people can just be together. What can you tell about these two?

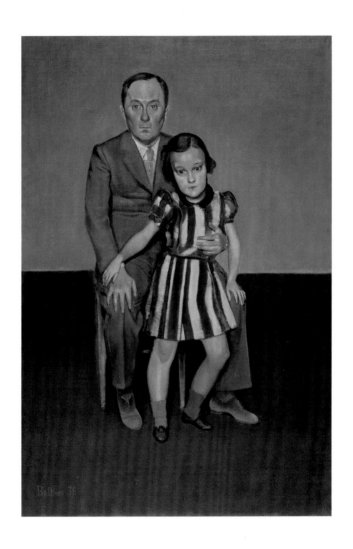

Balthus (Baltusz Klossowski de Rola). *Joan Miró and His Daughter Dolores*

Sometimes you have to look hard because there are so many people to see.

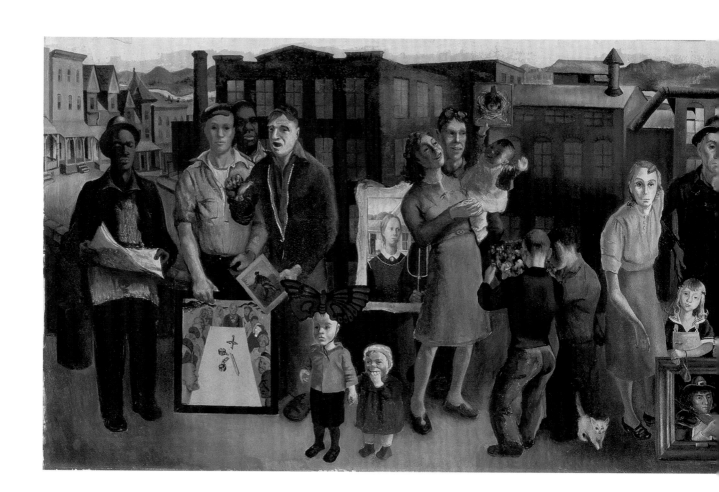

Honoré Sharrer. *Workers and Paintings*

Find all the children.

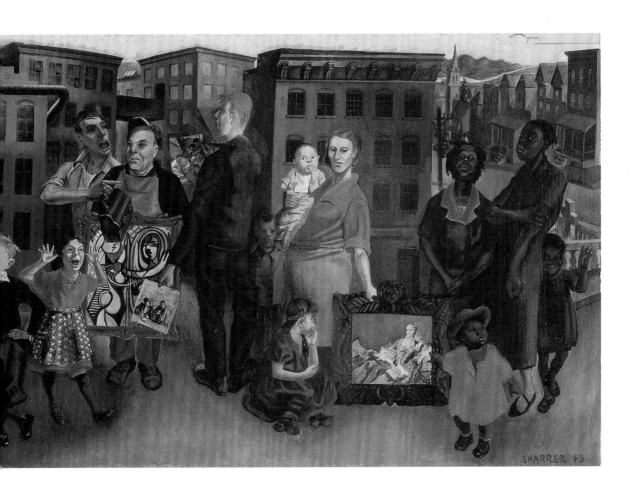

Sometimes you have to use your eyes *and* your imagination!

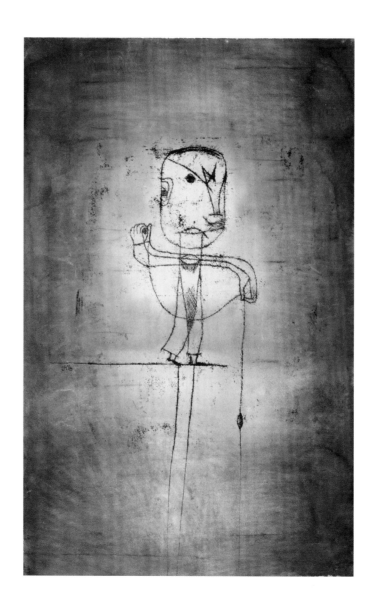

Paul Klee. *The Angler*

Could you ever imagine that these were the same man?

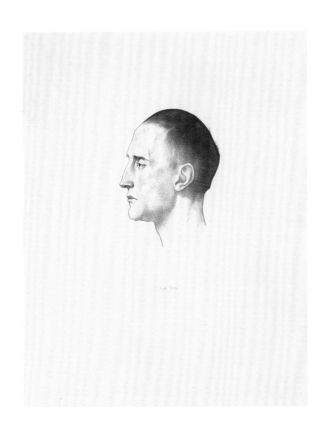 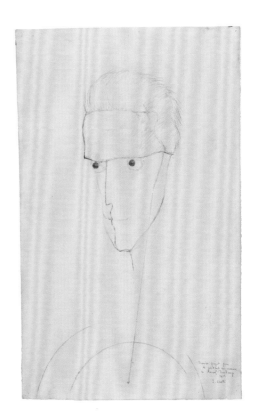

Joseph Stella. *Marcel Duchamp*; Jean Crotti. *Marcel Duchamp*

What do you think this boy is doing?

Can you tell where he lives?

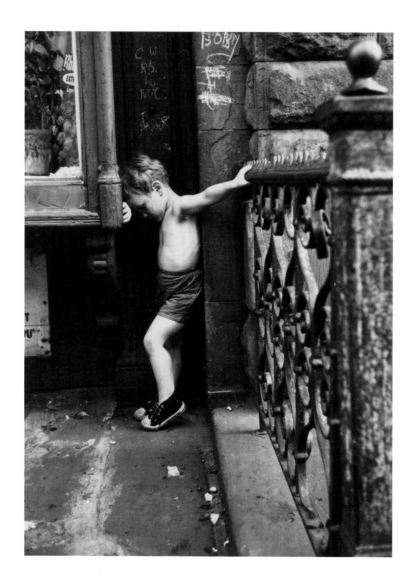

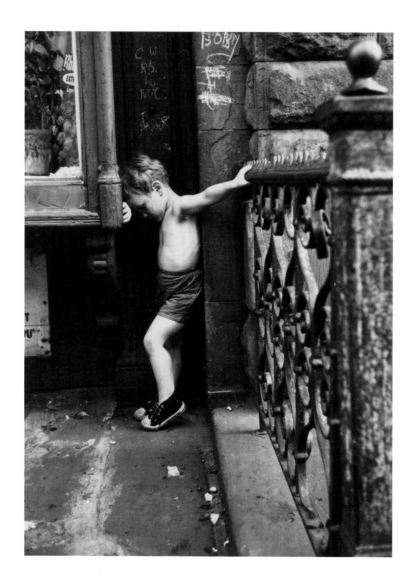

Ken Heyman. *Willie*

What about these warmly dressed people?

Can you guess what each might be looking at?

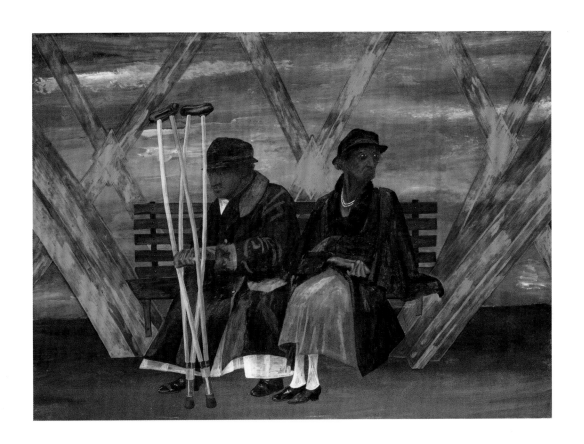

Ben Shahn. *Willis Avenue Bridge*

Can you tell how this woman feels by the look on her face?

What do you think she is doing?

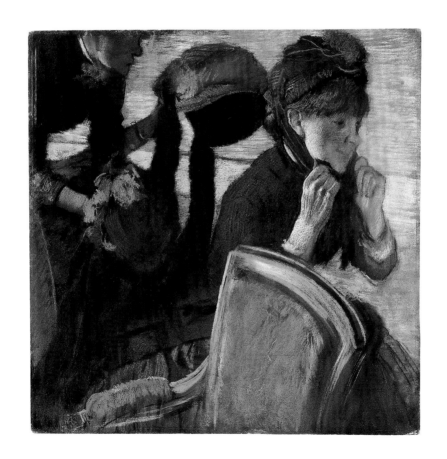

Hilaire-Germain-Edgar Degas. *At the Milliner's*

Look at each of these expressions. What feeling do you think each one describes?

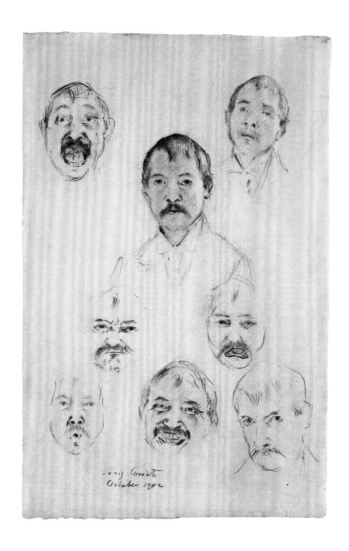

Guess what this girl is thinking?

Where do you think these two, at right, are?

Where are they going?

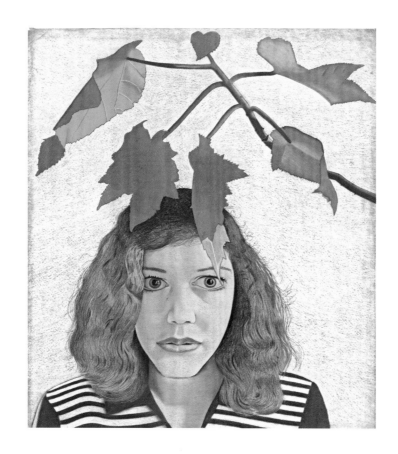

Lucian Freud. *Girl with Leaves*

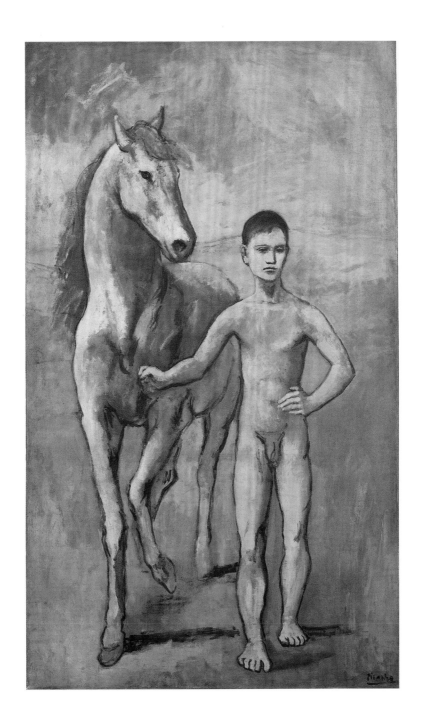

Pablo Picasso. *Boy Leading a Horse*

Look at how these people sit. Do you think they like having their picture painted?

How can you tell?

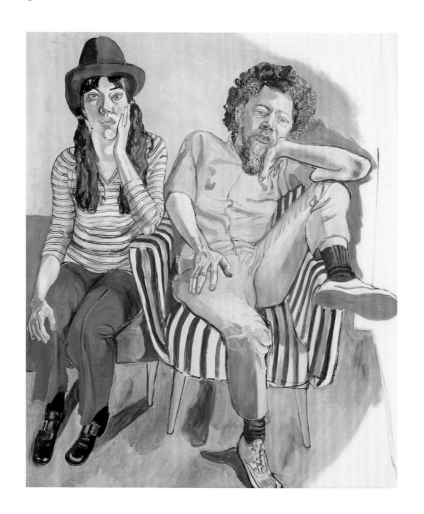

Alice Neel. *Benny and Mary Ellen Andrews*

What can you learn from looking at the faces and hands of these people?

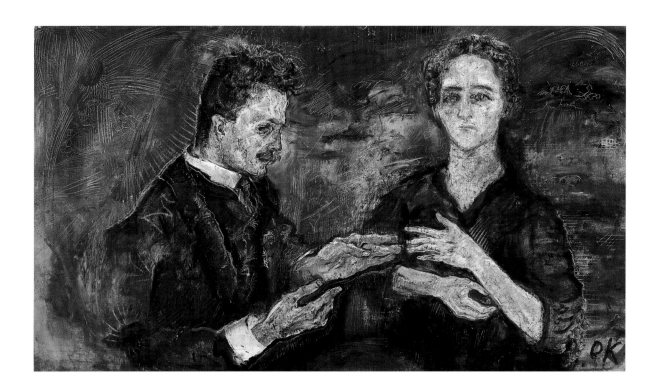

Oskar Kokoschka. *Hans Tietze and Erica Tietze-Conrat*

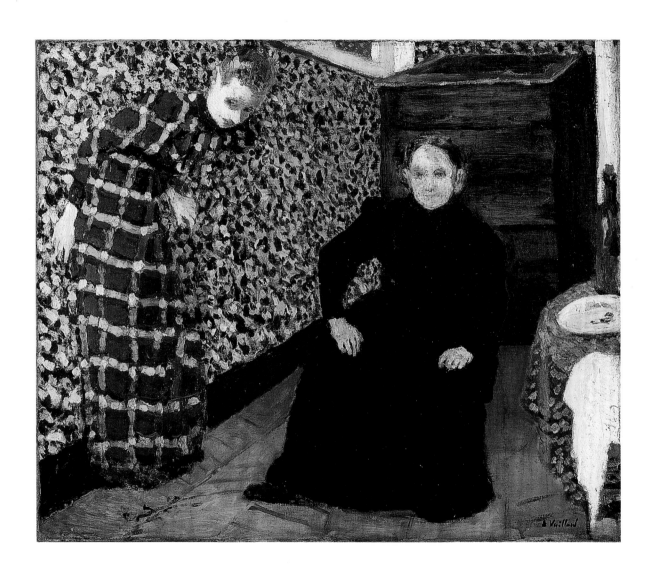

18 Édouard Vuillard. *Interior, Mother and Sister of the Artist*

Look at the woman sitting down.

What can you tell about her from the expression on her face?

Now look at the other one.

Can you guess what she is like by the way she is standing?

This picture gives you a lot to look at.

Who are these people?

What are they holding?

Why is that man on the ground?

Make up a story about these people.

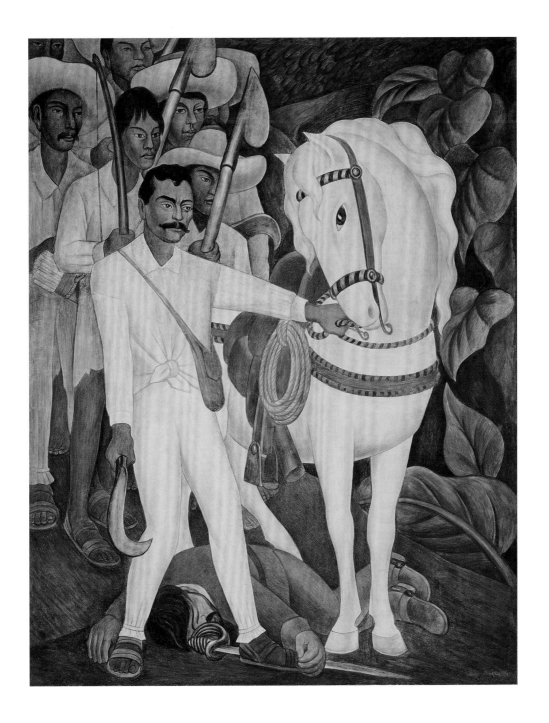

Diego Rivera. *Agrarian Leader Zapata*

Now it's time for you to draw pictures of people. Can you make young and old ones? Can you make them happy or serious? Can you draw them doing things? Can you make a mystery? How many ways can you draw yourself?

The art in this book is in the collection of The Museum of Modern Art in New York City, but you can find interesting pictures at any museum or gallery. You can also look for pictures and patterns in magazines, books, buildings, parks, and gardens.

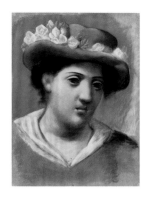

Page 1
Pablo Picasso
Woman with Flowered Hat. 1921
Pastel and charcoal on paper
25 1/4 x 19 1/2" (64 x 49.5 cm)
Gift of Jacqueline Picasso in honor of the Museum's continuous commitment to Pablo Picasso's art

Picasso used brightly colored pastels to make this serene-faced woman. Her eyes, nose, and brow might make us think of a figure cut from stone, maybe even a classical goddess. Her hat and collar, however, make her more peasant-like. Perhaps Picasso wanted us to relate the two.

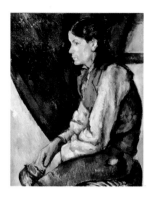

Page 2
Paul Cézanne
Boy in a Red Vest. 1888–90
Oil on canvas
32 x 25 5/8" (81.2 x 65 cm)
Fractional gift of Mr. and Mrs. David Rockefeller (the donors retaining a life interest in the remainder)

This boy's relaxed, slouching pose contrasts with the sharp intelligence of his wide-eyed gaze. You might also point out the rich quality of Cézanne's paint here.

Page 3
Fernando Botero
Mona Lisa, Age Twelve. 1959
Oil and tempera on canvas
6' 11 1/8" x 6' 5" (211 x 195.5 cm)
Inter-American Fund

It is not necessary to know da Vinci's *Mona Lisa* to appreciate the humor in the wide grin of this mischievous miss.

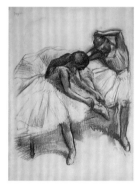

Page 4
Hilaire-Germain-Edgar Degas
Two Dancers. 1905
Charcoal and pastel on tracing paper, mounted on wove paper
43 x 32" (109.2 x 81.3 cm)
The William S. Paley Collection

Degas's deceptively simple studies of dancers are not always clearly readable. Where are these two? Are they sitting or standing? The dancer in front is probably fixing her toe shoe, but what about the other one?

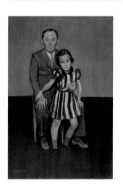

Page 5
Balthus (Baltusz Klossowski de Rola)
Joan Miró and His Daughter Dolores. 1937–38
Oil on canvas
51 1/4 x 35" (130.2 x 88.9 cm)
Abby Aldrich Rockefeller Fund

The artist Joan Miró and his daughter are posed rather stiffly, yet the way Miró holds the child and the way she leans against him suggest warmth and trust. Note how little background detail there is, as in Degas's *Two Dancers*.

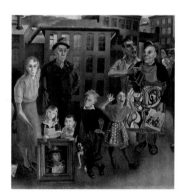

Pages 6–7
Honoré Sharrer
Workers and Paintings (detail).
1943, dated 1944
Oil on composition board
11 5/8 x 37" (29.5 x 94 cm)
Gift of Lincoln Kirstein

Against an urban backdrop, the artist depicts several family groupings, each holding a painting. Look at the variety of expressions and gestures to see what is going on.

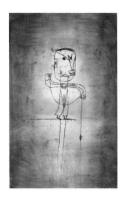

Page 8
Paul Klee
The Angler. 1921
Watercolor, transfer drawing, and ink
on paper
18 7/8 x 12 3/8" (47.6 x 31.2 cm)
John S. Newberry Collection

Klee's drawings often resemble children's, in that they are simple, playful, and imaginative. This means the viewer must think creatively to figure them out. For example, how many different faces exist here?

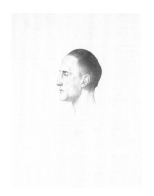

Page 9
Joseph Stella
Marcel Duchamp. c. 1920
Silverpoint on paper
24 1/4 x 18 3/4" (61.6 x 47.6 cm)
Katherine S. Dreier Bequest

Does this careful drawing, contemplative in pose and mood, tell us much about the subject, artist Marcel Duchamp? Can you be certain of his age? His personality? Compare his hairline, brow, nose, mouth, and chin to those parts in the next image.

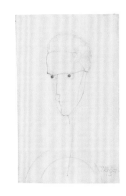

Page 9
Jean Crotti
Marcel Duchamp. 1915
Pencil on paper
21 1/2 x 13 1/2" (54.5 x 34.3 cm)
Purchase

In this drawing, almost a caricature, Duchamp's eyes are made to seem particularly intense, and his brow is stronger than in the other picture. Ask children to list all the things they might guess about this one man from the two representations of him.

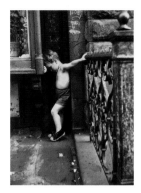

Page 10
Ken Heyman
Willie. 1959
Gelatin silver print
9 3/8 x 7" (23.4 x 17.5 cm)
Gift of the photographer

Children will have varied ideas about what is going on with this young boy. It is likely that they will see this as a city scene with a story. Point out the boy's expression and his clothing. Ask what they make of his outstretched arm.

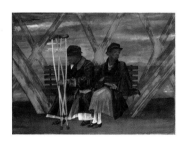

Page 11
Ben Shahn
Willis Avenue Bridge. 1940
Tempera on paper over composition
board
23 x 31 3/8" (58.4 x 79.4 cm)
Gift of Lincoln Kirstein

The alert eyes of the woman on the right could signal many things, from suspicion to watching for a bus. Don't miss the long white gown on the figure on the left. The diagonals call to mind the structure of a bridge, and you can recognize water beyond.

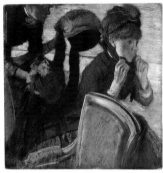

Page 12
Hilaire-Germain-Edgar Degas
At the Milliner's. c. 1882
Pastel on paper mounted on board
27 5/8 x 27 3/4" (70.2 x 70.5 cm)
Gift of Mrs. David M. Levy

This sweet-faced woman seems pleased with the hat she has tried on. Many things are left out of this picture, such as the mirror into which she is probably looking.

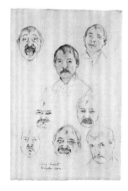

Page 13
Lovis Corinth
Self-Portraits. 1902
Pencil on paper
18 3/8 x 12 1/4" (47.7 x 31.1 cm)
Gift of The Lauder Foundation and given
anonymously (by exchange)

Look carefully at each face to see how the artist changes his eyes, and the different ways he shapes his mouth. Looking into a mirror and imitating the expressions might make it easier to talk about the moods set by each.

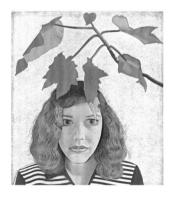

Page 14
Lucian Freud
Girl with Leaves. 1948
Pastel on gray paper
18 7/8 x 16 1/2" (47.9 x 41.9 cm)
Purchase

Consider what this young girl might be staring at so steadfastly, and also where she could be, given the leaves above her.

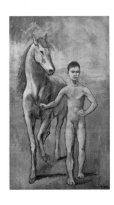

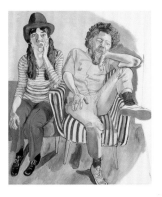

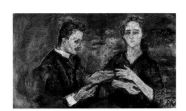

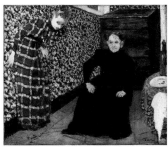

Page 15
Pablo Picasso
Boy Leading a Horse. 1905–06
Oil on canvas
7' 2 ⁷⁄₈" x 51 ⁵⁄₈" (220.6 x 131.2 cm)
The William S. Paley Collection

There are few details to help us tell the story of this boy and the beautiful horse he leads by an invisible rein. From their upraised legs, we can see that both seem to march resolutely forward. Where have they been? Where are they going?

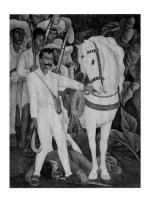

Page 21
Diego Rivera
Agrarian Leader Zapata. 1931
Fresco
7' 9 ³⁄₄" x 6' 2" (238.1 x 188 cm)
Abby Aldrich Rockefeller Fund

This is a portrait of a hero of the Mexican revolution, Emiliano Zapata. Behind are farmer-soldiers, armed with tools. He holds a scythe and leans back, perhaps restraining the huge horse. The steed seems to nuzzle his calm, wide-eyed master, who stands astride a fallen enemy.

Page 16
Alice Neel
Benny and Mary Ellen Andrews. 1972
Oil on canvas
60 x 50" (152.2 x 127 cm)
Gift of Agnes Gund, Blanchette Hooker Rockefeller Fund, Arnold A. Saltzman Fund, and Larry Aldrich Foundation Fund (by exchange)

Using colors as bright as van Gogh's, Alice Neel focused on the styles and personalities of her sitters. Their clothes, poses, and expressions give us strong impressions of the people she depicted. She deemphasized the emotional and psychological states that seem to be central in the next painting, by Kokoschka.

Page 17
Oskar Kokoschka
Hans Tietze and Erica Tietze-Conrat. 1909
Oil on canvas
30 ¹⁄₈ x 53 ⁵⁄₈" (76.5 x 136.2 cm)
Abby Aldrich Rockefeller Fund

The hands here seem to have wills of their own, as they reach toward each other, not quite meeting. The eyes, trancelike, stare at distant points. The colors, the strange little spikes, and the expressions of these people also contribute to a feeling of psychic intensity.

Page 18
Édouard Vuillard
Interior, Mother and Sister of the Artist. 1893
Oil on canvas
18 ¹⁄₄ x 22 ¹⁄₄" (46.3 x 56.5 cm)
Gift of Mrs. Saidie A. May

One of these figures stares straight out, and the other is bowing. Are they greeting us, the viewers, or some other visitors to their cozy, crowded corner? What might conversation with them be like?